IMAGES
*of America*

# GREATER U STREET

Since 1958, Ben's Chili Bowl at 1213 U Street has been internationally renowned, and has become an instantly recognizable U Street icon. Established in a former vaudeville theater built in 1909 and known as the Minehaha, the popular restaurant was opened by Ben and Virginia Ali. Ben's Chili Bowl and nearby Lee's Florist were the only two retail establishments along the U Street corridor to survive the construction of the U Street-Cardozo Metro Station during the 1980s. During Metro construction, a precarious system of wooden ramps was built to bridge the enormous construction pit on U Street. (Author's Photograph.)

IMAGES
*of America*

# GREATER U STREET

Paul K. Williams

ARCADIA

First published 2002
Reprinted 2003, 2005

Published by Arcadia Publishing
Charleston SC, Chicago IL, Portsmouth NH, San Francisco CA

Printed in the United States of America

Library of Congress Catalog Card Number: 2001099428

For all general information contact Arcadia Publishing at:
Telephone 843-853-2070
Fax 843-853-0044
E-mail sales@arcadiapublishing.com
For customer service and orders:
Toll-Free 1-888-313-2665

Visit us on the internet at http://www.arcadiapublishing.com

This 1894 map of the Greater U Street area shows the total number of outdoor privies, or outhouses, located within each block inside the boundary of the city, bordered on the north by Florida Avenue. Squares are noted with small numerals, privies are in large numerals. (Courtesy Author's Private Collection.)

# CONTENTS

# ACKNOWLEDGMENTS

The author would like to thank all individuals and friends who provided assistance during the production of this book, including one special individual named Gregory J. Alexander. This book is far from a complete history of such a complex neighborhood, and its purpose is to build on past resources and offer material that will enlighten, enhance, and perhaps surprise both residents and visitors alike.

Thanks go to Laura Daniels New at Arcadia Publishing. Special thanks go to the staff at the Library of Congress Prints and Photographs Division; Gail R. Redmann of the Washington Historical Society; and Peggy Appleman, Susan L. Malbin, and the staff the Washingtonian Division of the Martin Luther King Jr. Memorial Library for their many, many trips back and forth to their outstanding photographic resources on my behalf.

This book is dedicated to the late Henry P. Whitehead, a longtime resident and U Street history advocate who made it his mission to ensure that future generations of Washingtonians would never forget the "You" Street that once was. It is also dedicated to the late Thurlow Tibbs Jr., who first sparked my interest into U Street history when I became his neighbor and friend in 1992.

# INTRODUCTION

The neighborhood called Greater U Street today has a long and fascinating history. Originally the site of agricultural fields that became three major Civil War encampments during the conflict, the U Street corridor emerged as a racially diverse neighborhood that, by the 1910s, became home to a thriving and influential black community.

By 1872, U Street, Fourteenth Street, and Eleventh Street were paved with stone, providing easy transportation to this relatively undeveloped area within the city limits. In the years following the Civil War, this new neighborhood not only attracted a variety of professional people, but a variety of racial groups as well. Census records from 1880 reveal that blacks, whites, and mulattos were often found intermixed throughout the neighborhood, although African-American residents tended to be clustered in groups of labor-class dwellings farther away from the improved streets and trolley lines.

By 1887, the city's streetcar system was expanded to include much of the neighborhood. In the next 20 years, the area became developed with rows of town homes and commercial buildings on every square. Many of the older frame residences were replaced with more substantial and larger brick dwellings. The area continued to attract both blacks and whites of lower- to middle-income levels, and remained a social, economic, and racially diverse neighborhood until the beginning of the 20th century. At this time, groups of professional and middle-class whites began to emerge in close proximity of the streetcar lines on Seventh and Fourteenth Streets. Social forces and racial segregation legislation continued to change the diversity of the neighborhood until it became a predominantly African-American, middle-income area evolving during the first few decades of the 20th century.

During that time, suburban areas outside the city were beginning to attract a predominately white population, away from the intermixed neighborhoods of the inner city. This exodus, combined with restrictive covenants that barred African-Americans from other parts of the city, created a neighborhood surrounding U Street that was increasingly exclusive of whites.

By 1910, the neighborhood entertainment and commercial area centered on U Street, and African-American leaders at the time began to promote racial solidarity and self-sufficiency. This idea appealed to many African-Americans as they increasingly experienced the injustices of segregation and discrimination.

In addition to the large residential population, African-American churches, schools, businesses, and fraternal organizations did much to support and promote the neighborhood. Many articles and news features centered on the activities of the neighborhood, and these were

recorded in Washington's preeminent African-American newspaper, *The Washington Bee*.

Because of this building and development activity, the U Street corridor evolved into an area where African-American business and entertainment establishments thrived. Entertainment venues on U Street in the 1920s and 1930s included the following: Oriental Gardens, Lincoln Colonnade, Murry's Casino, Republic Gardens, Boulevard Cafe, Crystal and later Bohemian Caverns, Capitol City Ballroom, Hollywood Inn, the Dreamland Cabaret, and the Dunbar, Booker T, Howard, Lincoln, and Republic Theaters. Entertainers during this century that appeared on U Street have included Pearl Bailey, Ray Charles, Madame Evanti, Cab Calloway, Duke Ellington, Billie Holiday, Sammy Davis Jr., Ella Fitzgerald, Sarah Vaughn, Moms Mabley, Marian Anderson, Lena Horne, Red Foxx, Jelly Roll Morton, Louis Armstrong, Fats Walker, Bessie Smith, Mills Brothers, and Count Basie. Later, clubs along the street continued to host the early performances of entertainers who would go on to become legendary, such as Diana Ross and the Supremes, Aretha Franklin, and comedian Bill Cosby.

The U Street corridor continued to thrive until the urban riots of 1968 caused many of the residents to move to the suburban neighborhoods. The construction of the U Street/Cardozo Metro station along the corridor during the 1980s disrupted traffic and residents, causing most businesses that had led an early revitalization effort in the 1970s to fail.

After the opening of the Metro station in 1992, interest in this and other neighborhoods in Washington increased, spurring new construction and in many cases, displacement of elderly, long-term residents. A National Park Service memorial to the more than 200,000 black Civil War soldiers was erected at Tenth and U Streets beginning in 1997, and the area eventually became both a local and National Register historic district in January of 1999.

Louis Armstrong was photographed at Club Bali at 14th and T Streets in this picture from the 1940s. (Courtesy Prints and Photographs Division, Library of Congress.)

# One

# EARLY BEGINNINGS AND CIVIL WAR

## 1860 TO 1900

*The area south of today's Florida Avenue was part of the grand plan of Washington. It was completed by architect Pierre Charles L'Enfant, beginning in the 1790s, with the grid system of streets interrupted by broad avenues such as Vermont and New Hampshire that remain to this day. However, the area that is designated U Street today remained with agricultural and orchard uses for several decades at what was then the extreme northern edge of the city in the early 1800s. The area north of Boundary Street (Florida Avenue) was then heavily wooded. Howard University was established in 1867, overlooking the future corridor and named after Gen. Oliver Otis Howard.*

*The cleared and open landscape was an ideal condition for military encampments at the beginning of the Civil War, established to protect Washington and to serve as hospitals and holding areas for troops from various northern states. Campbell Hospital once occupied the area at what is today Florida Avenue and Sixth Street. Wisewell Barracks was at Seventh and P Streets, and Camp Barker was established at Thirteenth and R Streets. Following the war, streetcars were established along Seventh Street and Fourteenth Street to Florida Avenue, and with Washington's population swelling, many of the large parcels were divided and occupied with small frame and brick homes in the 1860s and 1870s. Frederick Douglass was one of the first real estate investors, purchasing three homes at Seventeenth and U Streets, where his son resided for the next several decades. Frame chapels and churches also dotted the landscape, such as one once located at Vermont Avenue and T Street, either moved or demolished as congregations increased in size and could afford more substantial buildings. Early builders, like Diller Bevis Groff, were building rows of townhouses and semi-detached homes in a speculative nature throughout the 1870s and 1880s, such as those he built in 1879 along the 1500 block of Caroline Street, and the U Street corridor emerged as an early city settlement.*

Campbell Hospital was established during the first few months of the Civil War as a refuge for wounded soldiers on land that today is occupied by the intersection of Sixth Street and Florida Avenue. At the time, the edge of the city was ringed with heavily forested areas and agricultural lands, an ideal setting for the camp. (Courtesy of Historical Society of Washington.)

Beginning in the 1860s, horse-drawn trolleys such as this Capital and Boundary car, numbered 27, carried passengers along what is today Florida Avenue at the edge of the city limits. (Courtesy of Washingtoniana Division, MLK Public Library.)

Christian Fleetwood was among the first group of 13 African-American Civil War soldiers to receive the Medal of Honor from the United States Congress for valor in war. Fleetwood resided at 319 U Street following the war, and later moved to 1419 Swann Street, in 1908. The memorial at Tenth and U Streets today honors more than 200,000 black soldiers that fought in the Civil War. (Courtesy of Prints and Photographs Division, Library of Congress.)

A Civil War camp coined "Meridian Hill" was located on Fifteenth Street near what is today Meridian Hill Park. It housed the seventh regiment New Jersey volunteers, with Colonel Revere leading the troops. (Courtesy of Washingtoniana Division, MLK Public Library.)

Howard University, located north of U Street along Seventh Street, gleans its name from Gen. Oliver Otis Howard, born in 1830. Following an education at West Point, he commanded 36 battles during the Civil War, starting with Bull Run in 1861. He is seen here in uniform after losing his left arm in the battle of Fair Oaks in 1862. He served as Howard University's first president from 1869 to 1874. (Courtesy of Moorland-Spingarn Center, Howard University.)

General Howard built himself this handsome home along Seventh Street near W Street in 1867 at the impressive cost of $20,000. Today, it is located on the campus and has recently been restored by Howard University. He left it and the surrounding land to the university named after him, and insisted that the school be "above all segregation or race prejudice." (Courtesy of Moorland-Spingarn Center, Howard University.)

The Freedman's Hospital was constructed in 1868, on the site of what is a portion of the Howard University Hospital just north of Ninth and U Streets. It was intended to accommodate the freedmen and refugees streaming into the city after the end of the Civil War. Note that the upper sashes on the windows were lowered, acting as an early form of air-conditioning, when this image was taken in 1898. (Charities and Reformatory Institutions in the District of Columbia 1898 Report, Author's Collection.)

The Washington City Orphan Asylum was built by contractor James Naylor at the southeast corner of Fourteenth and S Streets beginning in June of 1865, at a cost of $24,170. In the spring of 1866, however, Secretary of State William Seward commandeered the building upon its completion for use by the state department. The federal agency occupied the building until 1875, at which time it was restored to its original purpose. There were 139 children living there by 1898. Today, the site is occupied by the Frontier public housing townhouses, recently renovated and privatized by Manna, Inc. (Charities and Reformatory Institutions in the District of Columbia 1898 Report, author's collection.)

The house at 1800 Vermont Avenue, at the corner of Eleventh Street, was built by Diller B. Groff in 1879 and was first owned by printer Edwin P. Goodwin. From 1921 to 1927, the small house served as the first building owned by Frelinghuysen University. This was a school led by noted educator Anna Julia Cooper, organized in 1907 for the education and betterment of working-class African Americans. (Courtesy of Historical Society of Washington.)

Henry A. Willard was an early real estate speculator in the U Street area, owning the square bounded by T, U, Seventeenth, and Eighteenth Streets. He created Willard Street to bisect the square and subdivided the land in 1868. (Courtesy of Prints and Photographs Division, Library of Congress.)

Noted abolitionist Frederick Douglass purchased the three houses, located at 2000 to 2004 Seventeenth Street, as a real estate investment in 1877. His son Lewis Douglass resided at 2002 Seventeenth from 1877 to his death in 1908. (Courtesy of Prints and Photographs Division, Library of Congress.)

The Washington Hospital for Foundlings was made possible in 1869 by the will of Joshua Pierce, but was not erected until 1887. It was located on Fifteenth Street between R and S Streets, where the Bishops Gate Condominium complex is today. By 1897, 538 white children had been admitted as orphans, only 108 were adopted, 34 remained at the facility that year, and the remainder died. The building was replaced in 1929 by a small chapel and school by St. Augustine's church. It was intended to adjoin a large, partially built cathedral. The foundation of the cathedral serves as the parking garage for the condominium project on the site today. (Charities and Reformatory Institutions in the District of Columbia 1898 Report, Author's Collection.)

The Children's Hospital of Washington was incorporated in 1870, and maintained a small wood frame building at Thirteenth and F Streets until it built, in stages, this large institution facing Thirteenth Street in 1878. The foundation purchased the Square 272 for $15,722.88, and built the hospital designed by J.G. Naylor for a total cost of $23,662.22. (Charities and Reformatory Institutions in the District of Columbia 1898 Report, author's collection.)

The incorporation papers for Children's Hospital, dating to 1870, declared that it was formed for the "gratuitous medical and surgical treatment of indigent children under the age of 12 years, without distinction of race, sex, or creed." Its surgical white ward is pictured above, c. 1898. (Charities and Reformatory Institutions in the District of Columbia 1898 Report, author's collection.)

The rear of Children's Hospital faced Twelfth Street and included an elegant gazebo and large rear yard between V and W Street. Following a period of abandonment, the expanded complex was torn down in 1998 to make way for the present-day housing located on the site. (Charities and Reformatory Institutions in the District of Columbia 1898 Report, author's collection.)

Children's Hospital's colored ward, opened in 1878, was captured for a report in 1898, shown above. During its first 16 years, the hospital provided care to 20,862 children and 70 percent were cured or improved in health. (Charities and Reformatory Institutions in the District of Columbia 1898 Report, author's collection.)

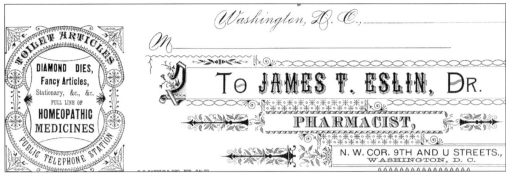

This richly detailed Victorian letterhead from the 1880s belonged to Dr. James T. Eslin, a pharmacist who operated a variety store at the corner of Ninth and U Streets. Among his offerings were "Diamond Dies," stationery, toilet articles, and homeopathic medicines. His store also served as the public telephone station. (Courtesy of author's private collection.)

Garfield Memorial Hospital once occupied the large parcel of land north of Florida Avenue at Tenth Street, one of many structures named following the assassination of the president. It was actually built as an expansion and addition to the Haw mansion, seen at left, beginning in 1883. (Charities and Reformatory Institutions in the District of Columbia 1898 Report, Author's Collection.)

The annual report of Garfield Hospital for 1886 shows that those admitted included 362 men, 207 women, 25 boys, and 10 girls. Forty-nine of these were African American people, and two were classified as Native Americans. Seen here is the "Public Ward" in 1898, when it was lit by gas fixtures and heated by a fireplace. (Charities and Reformatory Institutions in the District of Columbia 1898 Report, Author's Collection.)

This captivating image of Moriah George was taken in the rear yard of her house at 1624 Tenth Street. She had been born in a free black family in Virginia in 1834, and resided on Tenth Street until after her 100th birthday. (Courtesy of Historical Society of Washington.)

Thompson's Dairy founder, John S. Thompson, is seen here in his routine of delivering 10 gallons of milk per day in an elegant horse and wagon. The Dairy was founded in 1881 at Tenth and U Streets. (Courtesy of Washingtoniana Division, MLK Public Library.)

This Baptist Church, located on the southeast corner of Ninth and S Streets, was replaced by a larger, modern structure in the fall of 1945 that remains at the site today. (Washington Star photograph, November 17, 1945, Courtesy of Washingtoniana Division, MLK Public Library.)

Architect and builder Thomas Franklin Schneider was born in Washington in 1859, and would construct over 2,000 homes and buildings during his 45-year career, including the entire 900 block of Westminster Street, and the 900 block of T Street. (Courtesy of D.C. Archives.)

This early, undated image shows the newly completed Dutch Reformed Church on Fifteenth Street opposite Corcoran Street, nestled amongst fine townhouses in the row. (Courtesy of Washingtoniana Division, MLK Public Library.)

Wallach Place, which connects Thirteenth and Fourteenth Streets in a one-block stretch between T and U Streets, was named for William Douglas Wallach, illustrated here. Wallach became the second owner of the *Washington Star* newspaper after many years as a reporter on the government beat. (Courtesy of Washingtoniana Division, MLK Public Library.)

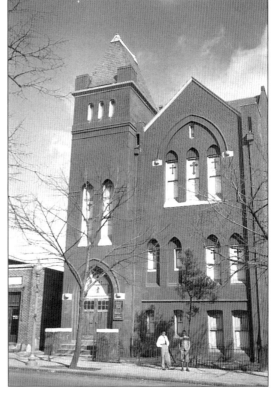

This church at the corner of Tenth and V Streets has been home to a variety of African-American congregations. The first church, the Trinity Methodist Episcopal, had moved its small wooden chapel from the intersection of Vermont Avenue and T Street to the present site in 1881. By 1896, it was home to the African New Church, and was expanded with plans provided by prominent architect Paul Peltz. (Courtesy of Prints and Photographs Division, Library of Congress.)

African-American churches, like Metropolitan Baptist in the 1200 block of R Street, often served as important performance venues for visiting black performers, like Leontyne Price, during the era of segregation in Washington. (Courtesy of Historical Society of Washington.)

The Metropolitan Baptist Church once dominated the 1200 block of R Street with this handsome structure. The original church building was demolished just months before the area gained historic protection under an expanded Logan Circle Historic District in the 1970s, and replaced with a modern structure. (Courtesy of Historical Society of Washington.)

The Portner Flats apartment building was one of Washington's most fashionable dwellings, as well as its largest, when it opened in 1897. It fronted on Fifteenth Street, and had a significant facade along the 1400 block of U Street at right. (Courtesy of Smithsonian Institution.)

Seen on the southern edge of St. Augustine's Catholic Church, the Portner Flats dominated the residential 2000 block of Fifteenth Street until it was torn down in 1974. It was razed to make way for an elderly housing project coined Campbell Heights, built in 1978. Portsmouth Flats was built by Washington brewer and investor Robert Portner. It featured 123 three-bedroom apartments and 30 hotel suites when it opened in 1897. (Courtesy of Historical Society of Washington.)

After World War II, the Portner Flats apartment building (at left) was converted to the Dunbar Hotel, named after local poet and writer Paul Laurence Dunbar. The name change was symbolic of the demographic shift from a predominantly white clientele to a predominantly African-American clientele. The 123 apartments were converted into 485 hotel rooms and a famous nightclub was established, catering to many distinguished visiting black entertainers during the next three decades. (Courtesy of Prints and Photographs Division, Library of Congress.)

The corner of the Portner Flats apartment building at Fifteenth and U Streets once featured these elaborate metal caryatids painted to resemble stone. The building was designed by architect Clement A. Didden Jr. Built in 1897, it received additions in 1899 and 1902 in response to the housing demand created by the Fourteenth Street streetcar. (Courtesy of Prints and Photographs Division, Library of Congress.)

These handsomely dressed professors from Howard University were photographed in front of Rankin Chapel on the campus in the 1890s. The university itself was established in 1867. (Courtesy of Moorland-Spingarn Center, Howard University.)

# Two

# THE BUILDING BOOM

## 1900 to 1920

Architects and builders began large-scale speculating on land and squares, including those comprising the U Street corridor, in the 1890s. They frequently subdivided large parcels into individual lots for townhouse development, and in some cases, enlarged former alleys to become actual streets, such as Caroline, Westminster, Wallach, and Willard Streets. Builders, such as Thomas Franklin Schneider, were beginning to complete entire rows of houses like the 900 block of T Street and sell the mass produced homes once they were completed. In fact, he went on to build more than 2,000 homes in the city.

Homes that had been built on U Street were converted to commercial uses about ten years after their erection. One example is the townhouse at 1355 U Street that became Republic Gardens in the 1910s, a club by the same name that remains there today. Major entertainment venues catering to a black crowd began as early as 1909, when the Minnehaha Theater was built at 1213 U Street, Ben's Chili Bowl today. In 1910, the Howard Theater at Seventh and T was constructed with a capacity of 1,200, predating the famed Apollo in Harlem by nearly a decade. The impressive True Reformer Building at 1200 U Street was begun in 1902 and hosted a myriad of social functions, parties, and even the first paid performance of the neighborhoods own Duke Ellington. Industrial Savings Bank, started by John Whitelaw Lewis, was one of the first African-American owned banks in the country when it opened at Twelfth and U Street in 1917. U Street continued to evolve as an entertainment corridor with the addition of the Dunbar Theater at Seventh and T Streets in 1919. These businesses supported hundreds of families of mixed races who moved into newly constructed homes along much of the 40 square blocks surrounding U Street to the north and south. In all, black-owned business increased from 15 in 1895 to more than 300 by 1920.

The "True Reformers Hall" at 1200 U Street was built by the United Order of True Reformers from 1902 to 1903. The True Reformers was a large Richmond, Virginia–based benevolent society that offered insurance and banking services to African Americans. The building was designed by John A. Lankford. Upon completion of the building, headlines in the white-owned *Washington Post* read, "Erected by Negroes, White Race Had No Hand in Any Part of Work." (Courtesy of Washington DC Archives.)

John Anderson Lankford, alleged to be the first registered black architect in Washington, designed the True Reformer Building at Twelfth and U Streets in 1902, when he was just 28 years old. His office was located just south of the U Street corridor, at 1448 Q Street, seen here in a rare image. Other prominent commissions included buildings for the African Methodist Episcopal Church, a client that led to multiple commissions throughout the country and abroad. (Courtesy of Washington DC Archives.)

These local youngsters take part in an exercise program in the auditorium of the True Reformer Building in the 1940s, when the Metropolitan Police Boys Club used it for a variety of activities. (Courtesy of Washingtoniana Division, MLK Public Library.)

Rooms in the True Reformer Building at 1200 U Street have been used for several purposes since the opening of the building. Pictured is an elegant dinner meeting of the "Baker's Dozen" group in the 1940s. Local musician Duke Ellington stated in his biography that he played his first paid performance in room number 5 in the building and charged a cover of 5¢ a person. (Courtesy of Historical Society of Washington.)

Mary Foote Henderson, the wealthy wife of Senator John B. Henderson, lived in a castle-like house at the northwest corner of Sixteenth Street and Florida Avenue. Mrs. Henderson was personally responsible for bringing many of the lavish homes and embassies to the Sixteenth Street neighborhood, many of which remain today. (Courtesy of Washingtoniana Division, MLK Public Library.)

The beautiful waterfall in Meridian Hill Park was designed by Howard W. Peaslee, whose use of exposed aggregate concrete in the walls of the park was the first application of its kind, artistically composed by John Joseph Early. Mary Foote Henderson's imposing castle-like house can be seen in the background. Of the original structure, only the brownstone wall survives to this day. (Courtesy of Washingtoniana Division, MLK Public Library.)

Shown here around the turn of the century, the Hawarden Apartment house at 1419 R Street was built in 1901 to the designs of architect George S. Cooper. Its sister house on the left, the Gladstone, was named for Britain's Prime Minister at the time, and his estate, Hawarden House. (Courtesy of Smithsonian Institution.)

The large building at 1420 U Street, housing Smith Storage, was built in 1905 in an era when moving and/or storing one's belongings entailed the use of a horse-drawn truck! The building today is home to Storage USA. (Courtesy of Washingtoniana Division, MLK Public Library.)

Technical High School, at the corner of Rhode Island Avenue and Seventh Street, was built for white students in 1902, seen in this photograph taken shortly after its completion. Built on the site of the Wheatley Brothers lumberyard, the school was later named McKinley Technical School, and then transferred into the black school system in 1928, when it was renamed Shaw Junior High School. Asbury Methodist Church converted the structure into the Asbury Dwellings for elderly residents beginning in 1977. The building to the right is the Lafayette Apartment building, one of Washington's first apartment buildings, which was designed by George Cooper and completed in 1898. (Courtesy of Prints and Photographs Division, Library of Congress.)

The 1928 track team from McKinley Technical High School poses in front of the entrance to their school at the corner of Seventh and Rhode Island Avenue. (1928 McKinley Yearbook, Authors Private Collection.)

This very rare image of the intersection of Fourteenth and U Streets, looking southwest, ran in a spring edition of the *Washington Star* in 1907. At the right are the National Radio Institute buildings under construction, where the Reeves Municipal Center is located today. The Smith Storage building at 1420 U Street can be seen in the center, established in 1905. The building is still serving in its original capacity today. (Courtesy of Washingtoniana Division, MLK Public Library.)

The buildings once located at the northwest corner of Fourteenth and U Streets (where the Reeves Municipal Center is located today) served as the headquarters of the National Radio Institute from 1914 to 1957. Washingtonians could learn various trades in the radio field. (Courtesy of Michael K. Wilkinson Collection.)

Only two years after the first YMCA had been organized in Boston, former slave Anthony Bowen, seen here, organized a YMCA for "colored men and boys" in Washington in 1892 at 1609 Eleventh Street. Although it relocated to 1816 Twelfth Street in 1912, the building was not named the "Bowen YMCA" until 1972. (Courtesy Anacostia Museum, Smithsonian Institution.)

This photograph, taken on Thanksgiving Day in 1908, shows President Theodore Roosevelt speaking before laying the cornerstone of the Twelfth Street YMCA at 1816 Twelfth Street. It was designed by one of the first registered black architects in the country, William Sidney Pittman, a son-in-law of Booker T. Washington. (Addison Scurlock Photograph, Library of Congress Prints and Photographs Division.)

While young, Supreme Court Justice Thurgood Marshall was a member of the Twelfth Street YMCA, and met there with contemporaries early in his career in planning important Civil Rights gatherings, writings, and strategies. The building is today named the Thurgood Marshall Center for Service and Heritage. (Courtesy of Prints and Photographs Division, Library of Congress.)

The Twelfth Street YMCA was the first African-American YMCA in the United States. The club had met in various places throughout the city until enough money was raised to build a permanent home on Twelfth Street. Construction lasted from 1907 to 1912, and required $100,000. The lobby of the building is shown here, c. 1913. (Courtesy of Moorland-Spingarn Center, Howard University.)

The Twelfth Street YMCA included a large gymnasium at the rear that still remains to this day, seen here with boys being taught proper exercise in 1913. (Courtesy of Moorland-Spingarn Center, Howard University.)

This undated photograph shows the ground floor north lobby area of the Twelfth Street YMCA shortly after its completion, furnished with arts-and-crafts style furniture, which was popular at the time. (Courtesy of Prints and Photographs Division, Library of Congress.)

Poet and writer Langston Hughes called the Twelfth Street YMCA home in the 1920s, while writing his first published poetry. (Portrait by Winold Reiss, National Portrait Gallery, Smithsonian Institution.)

Colored Americans
OF WASHINGTON, D. C.
UNITE TO-DAY
Attend War Workers Meeting
Thurs., October 28, 1943
*1 to 2.30 P. M.*
AT Y. M. C. A. AUDITORIUM
1816 12th Street, N. W.
DO YOU WANT: 1 Equality of Status for the Negro and White People?
2  Jim Crow in the Army and Navy abolished?
3  Better Housing Conditions?
4  Race Segregation abolished?
5  To hold your jobs after the war?
6  Permanent Fair Employment Practice Committee?
THEN HEAR
E. PAULINE MYERS, THURMAN DODSON AND OTHERS

Save the F. E. P. C. to-day
Join the March on Washington Movement
Invest Your Dollar in the Liberation of Negro Citizens
Sponsored by the Washington Division
March On Washington Movement

The Twelfth Street YMCA was also a gathering place for black community residents and visitors organizing their right to various freedoms enjoyed by the white population. Consequently, it often became the central meeting point for Washingtonians, evidenced by this flier from 1943. (Courtesy of Henry P. Whitehead.)

The famed Howard Theater at Seventh and T Streets opened on August 22, 1910 as the first legitimate theater for blacks in the city. It had a seating capacity of 1,200 and booked a variety of musical, vaudeville, jazz, and sporting events until the stock market crash of 1929. Pearl Bailey had once been employed as a chorus girl, Duke Ellington was featured as the opening act when the theater reopened in 1931, and Diana Ross and the Supremes held a concert here in 1962. The building was stripped of its ornamentation and has been abandoned since 1970. (Courtesy of Prints and Photographs Division, Library of Congress.)

Duke Ellington was captured on the Howard Theater stage by noted photographer Robert H. McNeill in the early 1940s. The world-renowned entertainer got his start in 1917 at the nearby True Reformer Building, when he put on his first paid performance by charging 5¢ admission to each of his young friends who attended. (Photograph by Robert H. McNeill.)

Photographer Addison N. Scurlock was the premier photographer for the African-American community, capturing important social events and creating portraits at his studio, which opened at 900 U Street in 1911. (Courtesy of Henry P. Whitehead.)

Prolific developer Harry Wardman was responsible for building many of the elegant apartment houses in and around the U Street corridor, including the famed 1909 Northumberland at 2039 New Hampshire Avenue. (Courtesy of Prints and Photographs Division, Library of Congress.)

The enormity of Griffith Stadium at Sixth and U Streets is evident in this aerial photograph, with the Freedman's hospital to the north, and Sixth Street on the right. The site of the stadium is now occupied by Howard University Hospital. (Courtesy of Washingtoniana Division, MLK Public Library.)

Washington businessman Clark Griffith built the renowned Griffith Stadium at Seventh and V Streets in 1914. The Washington Senators baseball team called the stadium home and beat the New York Giants there to capture the World Series title in 1924. It was also used by black teams, including the Washington Elite Giants, the LeDroit Tigers, the Washington Pilots, and the Homestead Grays. (Courtesy of Prints and Photographs Division, Library of Congress.)

President Roosevelt threw the first ceremonial pitch to open the 1940 baseball season at Griffith Stadium. To the President's left is Postmaster General Farley, and at right are Joe Cronin and Bucky Harris, managers of opening day's two opposing teams. This *Washington Star* photograph ran April 16, 1940. (Courtesy of Washingtoniana Division, MLK Public Library.)

Baseball mogul Clark Griffith, after whom Griffith Stadium was named, is shown on April 19, 1949 pointing out photographs of some of the opening days of years past, in which presidents are throwing the ceremonial first pitches. (Courtesy of Washingtoniana Division, MLK Public Library.)

Griffith Stadium was a celebrated arena, host to all cultures, ages, and athletic abilities. This photograph depicts the unusual meeting of the Howard University baseball team and the Mainichi of Japan at the American League in 1927. (Courtesy of Moorland-Spingarn Center, Howard University.)

Five thousand school children "dance for health" on May 17, 1946, at this Griffith Stadium gathering of African-American elementary school pupils demonstrating physical fitness. (Courtesy of Washingtoniana Division, MLK Public Library.)

Josh Gibson, considered by many to be the best Negro League player of all time, won 9 home run titles in his 13 complete seasons at Griffith Stadium. (Courtesy of Moorland-Spingarn Center, Howard University.)

Fans seen here leaving Griffith Stadium may have attended major league baseball, National Negro League baseball, Howard University football, high school drill competitions, or even the first games of the Redskins. The Redskins played here from 1937 until they moved to RFK Stadium in 1963. (Courtesy of Prints and Photographs Division, Library of Congress.)

This forlorn image of Griffith Stadium being demolished ran in the May 14, 1965 issue of the *Washington Post*. (Courtesy of Washingtoniana Division, MLK Public Library.)

This large building, at the corner of Fourteenth and T Streets, was built in 1919 for the R.L. Taylor and H. Herbert Smith Ford car dealership. With 65 employees, the company switched allegiance and began selling Chevrolets in 1926. The building today serves as a church facility. (Courtesy of Author's Private Collection.)

These unidentified individuals posed in their automobile in front of the brick houses at 1103 to 1107 S Street, part of an entire block that was built between 1872 and 1874. (Courtesy of Prints and Photographs Division, Library of Congress.)

Author Georgia Douglas Johnson resided at 1461 S Street along with her husband Henry, who became the city's recorder of deeds in 1908. Her first book of poetry was titled *The Heart of a Woman*, and she went on to write additional books, plays, and song lyrics. (Courtesy of Moorland-Spingarn Center, Howard University.)

The study in the Johnson home at 1461 S Street is shown here with Henry Johnson in the foreground. The study was home to Saturday evening gatherings during the "Washington Renaissance" of elite and well-educated African Americans during the first part of the century. Guests at the renowned gatherings included Alain Locke, Langston Hughes, Jean Toomer, and Carter Woodson, who is credited with establishing Black History Month. (Courtesy of Moorland-Spingarn Center, Howard University.)

The Industrial Savings Bank, still located at Eleventh and U Streets, was established by John Whitelaw Lewis in 1919, seen here. The building was designed by black architect Isaiah T. Hatton. Lewis also financed the building across the street from the bank at 2001 Eleventh Street, as well as the Whitelaw Hotel a few blocks away at Thirteenth and T Streets. (Courtesy of Henry P. Whitehead.)

## The
# Industrial Savings Bank

JOHN W. LEWIS, President and Organizer.

The Bank Now Has 3,000 Depositors, with a Savings Account Amounting to $137,082.35.

Corner Eleventh and U Streets, N. W.

WASHINGTON, D. C.

Customers were photographed with a bank teller at the Industrial Savings Bank, Eleventh, and U Streets, by Robert H. McNeill in the early 1940s.

The guest register of the Whitelaw Hotel in the late 1920s included room charges and signatures of Edward "Duke" Ellington as a guest. Ellington grew up and lived close by at 1806 Thirteenth Street from 1910 to 1914. He also lived at 1816 Thirteenth Street from 1915 to 1917. (Courtesy of Historical Society of Washington.)

During the time Washington was segregated, the Whitelaw was one of the few places visiting African Americans could stay and residents could hold dinners, dances, and parties, such as the 1941 Spring Frolic for which this invitation was printed. (Courtesy of Henry P. Whitehead.)

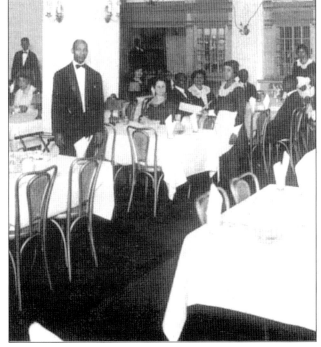

The Whitelaw Hotel at Thirteenth and T Streets opened in 1919 as the first apartment-hotel for African Americans. Designed by local black architect Isaiah T. Hatton, it was erected at a total cost of $158,000. (Courtesy of Smithsonian Institution.)

The elegant dining room of the Whitelaw Hotel is seen here in the 1920s, shortly after the building opened. The room was lighted by long rows of stained glass depicting food items and floral arrangements. (Courtesy of Prints and Photographs Division, Library of Congress.)

The Whitelaw's kitchen served many elite African Americans of the day whom were staying at the hotel and visiting its elegant ground floor dining room. Among the many prominent guests were Duke Ellington, Cab Calloway, and boxer Joe Louis. (Courtesy of Prints and Photographs Division, Library of Congress.)

The Whitelaw Hotel was financed by John Whitelaw Lewis, a black laborer who had come to Washington in 1894 with Coxy's Army of the unemployed. Lewis went on to found the industrial Bank at Eleventh and U Streets. By 1919, he was able to offer local and visiting African Americans a luxury hotel and apartment house furnished with fineries of the day, as seen in this lobby photograph taken shortly after it opened. (Courtesy of Historical Society of Washington.)

# *Three*

# THE BLACK BROADWAY
## 1920 TO 1930

*With ample space for performances in the area's many theaters, the U Street corridor continued to expand in the 1920s with additional smaller clubs, after-hours venues, and private gatherings for musicians, jazz performers, and the black cultural elite. Additional theaters were constructed including the Booker T Theater in the 1400 block of U Street, and the famed and elegant Republic Theater in the 1300 block of U Street, both of which have since been demolished. The first-run movie house and performance stage was built as the Lincoln Theater, between 1921 and 1923 at 1215 U Street. Club Crystal Caverns opened in 1926 in the basement of 2001 Eleventh Street in a cave-like setting that has hosted performers from Pearl Bailey to Aretha Franklin during its heyday. It operated under several different names until the mid-1970s, and still exists today. Speakeasies in private basements and the Lincoln Colonnade often kept patrons entertained long after the official last call in the clubs. Therefore, the U Street corridor thrived and was coined the "Black Broadway" by astonished visitors and locals alike.*

Billie Holiday was one of the many famous recording artists that performed in entertainment venues along U Street. Photographer Carl Van Vechten captured her on March 23, 1949. (Courtesy of Prints and Photographs Division, Library of Congress.)

The Republic Theater at 1343 U Street, seen here in the 1940s, was one of three movie palaces serving the African-American community from its opening in the mid-1920s until it was demolished in 1977. It was torn down to make way for a Metro construction staging facility. It was part of the District Theater chain owned by Abraham E. Lichtman, serving the black community in the city, Maryland, and Virginia. (Photograph by Robert H. McNeill.)

Howard University Professor Alain Leroy Locke authored *The New Negro* in 1925, in it alerting the world that a cultural revolution was taking place amongst African Americans in New York, Washington, and other cities. He was frequently seen at the Saturday socials held at Georgia Douglas Johnson's home at 1461 S Street. (Courtesy of Moorland-Spingarn Center, Howard University.)

Central High School, pictured here in 1923 shortly after its completion, has dominated the hill overlooking U Street ever since. That year, 17 nationalities were represented at the school and it claimed the Minister to China as one of its distinguished alumni. It was later renamed Cardozo High School. (Courtesy of Author's Private Collection.)

The stately Lincoln Theater was captured on October 4, 1949 by photographer John Wymer. At the time, a portion of the storefront was being used as a record shop. It was built in 1921 and featured both stage acts and first-run movies. Thompson's Dairy building can be seen at the far right. (Courtesy of Historical Society of Washington.)

Patrons at the Lincoln Theater at 1215 U Street were greeted by handsomely dressed ushers in the lobby in this 1940s-era photograph. First Lady Eleanor Roosevelt and heavyweight boxing champion Joe Louis once attracted huge crowds for a benefit while Louis Brown played the theater's Manuel Mohler organ in the 1920s. (Photograph by Robert H. McNeill.)

At the opening of the controversial "Gone With the Wind" movie at the Lincoln Theater in 1939, local black protesters did their best to curtail attendance in front of theater manager Rufus Byars. (Courtesy of Addison Scurlock Photograph, Library of Congress Prints and Photographs Division.)

Behind the Lincoln Theater was once located the Lincoln Colonnade, with access from the main lobby of the theater provided through a long brick tunnel. The dance hall hosted a variety of notable performers and after-hours events, as seen in this advertisement for Cab Calloway and his Cotton Club Orchestra. (Courtesy of Henry P. Whitehead.)

A quiet intersection when this image was taken in the 1920s, this building at Sixteenth and U Streets was first utilized as an automobile showroom. In subsequent years, the building became the home of the National Radio Institute. In the 1960s, a third floor was added, and Pride, Inc., a job development organization founded by Marion Barry, took over the building. As is widely known, Barry would rise from his 1960s civil rights activism to become the longtime mayor of the city of Washington. (Courtesy of Historical Society of Washington.)

Another performer playing to the crowds of U Street was Bessie Smith, photographed by Carl Van Vechten on February 3, 1936. (Courtesy of Prints and Photographs Division, Library of Congress.)

These members of the St. Augustine Catholic Church were captured on the steps of their church at Fifteenth and L Streets in the 1920s. The black congregation, formed in 1858, took the highly unusual step of merging with a white congregation in 1961. It then moved to the former St. Paul's Roman Catholic Church at Fifteenth and V Streets, where it remains today. (Courtesy of St. Augustine Church Archives.)

Thompson's Dairy was the oldest dairy in the city, taking up most of the block bounded by Eleventh, Twelfth, U, and V Streets. This handsome addition, facing Eleventh Street just north of Industrial Bank, was built in 1928. The Dairy was torn down in the 1970s and was eventually replaced by the Lincoln Condominium project, which began in 1998. (Courtesy of author's private collection.)

This small brick building at 1344 U Street served as the location of John Goins Printing, beginning about 1910. John Goins' wife, Gregoria, was an accomplished musician and educator and ran the Gregorian Studio of Music. Her mother, Sarah L. Fraser, was an early African-American physician in the city with an office on Thirteenth Street near Logan Circle. (Courtesy of Moorland-Spingarn Center, Howard University.)

Printing and book presses can be seen at the 1344 U Street home of Goins Printing in this photograph taken in the 1920s. (Courtesy of Moorland-Spingarn Center, Howard University.)

Employees of Goins Printing at 1344 U Street can be seen working on a linotype machine, which operated like a typewriter, dropping individual letters mounted on lead in preparation for the printing press. (Courtesy of Moorland-Spingarn Center, Howard University.)

Printer John Goins enjoys his roadster with his wife, Gregoria, at his side. (Courtesy of Moorland-Spingarn Center, Howard University.)

The sign of the Lincoln Theater can be seen at the very left edge of this 1940 photograph by Robert H. McNeill, looking east on U Street from Thirteenth Street. The Theater was built in 1921 as one of three first-run movie theaters clustered on U Street. It is now the only one remaining. The lights in the background shone from Griffith Stadium, at the site where Howard University Hospital now stands. (Photograph by Robert H. McNeill.)

The drugstore building on the northeast corner of Eleventh and U Streets has housed in its basement, through much of its history, a unique nightclub. Since opening in 1926 as the Crystal Caverns, this space has featured a subterranean theme, with stalactites and stalagmites constructed throughout to replicate the feel of a cavern. Through the years, the club has played host to a variety of top-name black entertainers, from Pearl Bailey to Aretha Franklin. Guests dined and drank under the stalactites and stalagmites awaiting each evening's shows. (Courtesy of Moorland-Spingarn Center, Howard University.)

Pearl Bailey, with cigarette, is seen here along with guests at the Bohemian Caverns nightclub, one of the many incarnations of the cave-like atmosphere that dominated the club in the basement of 2001 Eleventh Street. The building, which had a drugstore on the ground floor, was built by John Whitelaw Lewis. The club has recently been recreated to its former glory by local businessman Al Afshar. (Courtesy of Moorland-Spingarn Center, Howard University.)

This souvenir from the club Crystal Caverns dubbed the club "the rendezvous of the socially elite." (Courtesy of Gelman Library, George Washington University.)

The Federal Security Storage building at 1707 Florida Avenue, at Ontario Road, was built in 1925 and declared "one of the most beautiful and best-equipped warehouses in the country" by *Distributing and Warehousing* magazine. (Courtesy of author's private collection.)

Designed by architect Charles H. Moores of New York, the interior reception room of the Federal Storage facility at 1707 Florida Avenue was sparsely furnished with gothic furniture, which was popular at the time. (Courtesy of Author's Private Collection.)

Lillian Evans Tibbs, otherwise known as "Madame Evanti," was born in 1890 and earned a music degree from Howard University before becoming one of the first black lyric sopranos to travel throughout Europe. The only European State that did not welcome her was Germany. In fact, the country barred her entry in 1932. Stateside, she lived in the house at 1910 Vermont Avenue, later the home of the Evans-Tibbs collection, a major collection of African-American art owned by Tibbs' grandson, the late Thurlow Tibbs Jr. (Courtesy of Moorland-Spingarn Center, Howard University.)

Jean Toomer was born in 1894 in Washington and often passed as a white person, despite being an integral part of the black community. While living at 1341 U Street in 1923, Toomer published *Cane*, a book of short stories and prose based upon his experiences in Georgia and life on Seventh Street in Washington. (Courtesy of Prints and Photographs Division, Library of Congress.)

Dancer John Bubbles performed at the Howard Theater at Seventh and T Streets during its heyday from 1910 to 1919, when both white and black audiences enjoyed the various shows in harmony. This photograph was taken by Carl Van Vechten on December 27, 1935. (Courtesy of Prints and Photographs Division, Library of Congress.)

Members of the Lincoln Temple Congregational Church were photographed on October 14, 1928 attending the dedication ceremony of the building in the elegant dress of the day. The church is located at Eleventh and R Streets. (Courtesy of Historical Society of Washington.)

A dancing Amos Williams was caught on film with his chorus girl at Club Bali at Fourteenth and T Streets, for the February 1950 issue of *Holiday* magazine by photographer Roger Coster. (Courtesy of Author's Private Collection.)

Cab Calloway played in several venues along U Street, including gigs at Murray's Palace Casino, located on the second floor of 922 U Street. He was photographed here on January 12, 1933 by Carl Van Vechten. (Courtesy of Prints and Photographs Division, Library of Congress.)

This elegant advertisement for Club Bali at Fourteenth and T Streets featured Louis Jordan and his "Tympany Five," when the club was owned by Benny Caldwell in the 1940s. (Courtesy of Henry P. Whitehead.)

Louis Armstrong is photographed here performing at Club Bali at Fourteenth and T Streets in the 1930s. Pictured with Armstrong, from left to right, are Barney Bigard, Jack Teagarden, and Earl "Fatha" Hines. (Courtesy of Historical Society of Washington.)

Ella Fitzgerald and the Philip Morris Man were photographed at Club Bali in the 1930s by photographer Robert H. McNeill. (Courtesy of Smithsonian Institution.)

## NEW BALI

•Now A Popular-Price Restaurant

1901 - 14th St., N.W.                    DUpont 7544

## NOW PLAYING

# Ella Fitzgerald

This is an advertisement for Ella Fitzgerald to headline at the New Bali, a name derivative for the Club Bali at Fourteenth and T Streets. (Courtesy of Henry P. Whitehead.)

Employees of the Lula B. Cooper French Beauty Salon on U Street were the subject of photographer Robert H. McNeill in 1939. (Courtesy of Prints and Photographs Division, Library of Congress.)

These homes, located at Florida Avenue and Nineteenth Street, were photographed in 1935 by Carl Mydans. The pictures were taken for the Office of War Information and annotated "A fine old home alongside a shabby Negro house." (Courtesy of Prints and Photographs Division, Library of Congress.)

Joe Turner's Arena was once located at the corner of Fourteenth and W Streets, and was home to African-American musical and dramatic performers of the day. (Courtesy of Prints and Photographs Division, Library of Congress.)

This small advertisement announces the appearance of "The Clovers" at Joe Turner's Arena. The building was torn down following the racial disturbances of 1968. (Courtesy of Henry P. Whitehead.)

**TURNER'S ARENA**

CORNER 14th AND W STREETS, N.W.

presents

*Sunday, March 15*

# THE CLOVERS

PLUS

## CHOKER CAMPBELL

AND HIS BAND

*Dancing 9 'til 2*

Noted Civil Rights leader Mary McLeod Bethune was photographed in the 1930s picketing the Peoples Drug Store at Fourteenth and U Streets. The store only hired white clerks, despite catering to a predominantly black population at the time. (Courtesy of Historical Society of Washington.)

## To All
### FAIR-MINDED PEOPLE
## JUSTICE
### IS ESSENTIAL TO AMERICANISM.

For one year (since June 25, 1938) The New Negro Alliance has picketed two of Peoples Drug Stores located in colored neighborhoods because the firm has refused to employ or promote colored persons as clerks in these stores where the preponderance of their trade is colored. They insist on keeping their colored employees in the most menial positions and at the average salary of $15.79 per week, although seeking the colored trade which keeps these stores profitable.

Peoples Policy is Essentially Unfair and Un-American.

WHAT YOU CAN AND SHOULD DO :

# STAY OUT
### OF ALL
## PEOPLES DRUG STORES

Write the management in Protest.    Fight always for Justice and Americanism.

NEW NEGRO ALLIANCE        1333 R St., N. W.

The Alliance is not connected with any other organization, political or otherwise, and is supported entirely by membership fees and donations.        PRINTING DONATED

This notice of the protest against Peoples Drug Store was produced in 1939 by the influential New Negro Alliance, which was then located at 1333 R Street. (Courtesy of Historical Society of Washington.)

# Four

# THE CITY WITHIN
# A CITY
## 1940 TO 1950

*With racial segregation increasing in Washington, eventually becoming law, the well established U Street corridor naturally focused on becoming an area that could be self-sustaining, offering black residents everything they needed or desired. This included banks, grocery stores, clothing stores, sports, schools, a florist, funeral homes, newspapers, clubs and movie houses, and elegant large Victorian era homes maintained to perfection. Local papers coined U Street as the "Blackman's Connecticut Avenue" during this time.*

*U Street meeting spaces, such as the Twelfth Street YMCA, were home to many gatherings of early Civil Rights activists like Thurgood Marshall. Marshall prepared the landmark legal strategy for the 1954 Supreme Court case Brown vs. Board of Education at this YMCA. Literary giants like Alain Locke and Langston Hughes met with other educators, artists, and intellectuals in weekly social gatherings at the True Reformer Building, the Whitelaw Hotel, and in private homes. Much of the neighborhood was photographed by local resident Robert H. McNeill and John Wymer during this period, in addition to several studies by famed photographer Gordon Parks.*

Photographer Robert H. NcNeill took this image of the employees of the Table Supply Store at 2007 Fourteenth Street for the November 16, 1940 edition of the *Washington Tribune*. In this photo, from left to right, are Lawrence Jones, Henry Hiel, Charles Boyd, Harry Green, and manager Douglas Williams. (Courtesy of Prints and Photographs Division, Library of Congress.)

The "Tea" Street Post Office opened in September of 1940 after complaints by local black employees that they were denied window positions next to their white counterparts at the main Post Office next to Union Station. (Courtesy of Prints and Photographs Division, Library of Congress.)

This peanut vendor on Seaton Place was captured by noted photographer Gordon Parks in June of 1942. (Courtesy of Prints and Photographs Division, Library of Congress.)

These unidentified residents of Seaton Place are pictured here in June of 1942 in a photograph taken by Gordon Parks. (Courtesy of Prints and Photographs Division, Library of Congress.)

Photographer Gordon Parks took this image of an unidentified grandfather and his granddaughter on Seaton Place in June of 1942. Seaton Place was named after William Winston Seaton, mayor of Washington from 1840 to 1850. (Courtesy of Prints and Photographs Division, Library of Congress.)

This young boy lost a leg when he was hit by a streetcar while playing on the street. He was photographed by Gordon Parks in his doorway on Seaton Place in June of 1942. (Courtesy of Prints and Photographs Division, Library of Congress.)

The Greater U Street neighborhood was frequently the scene of animated protests, including this c. 1940 march through the intersection of Eleventh and S Streets and Vermont Avenue to encourage black bus and streetcar operators. (Courtesy of Moorland-Spingarn Center, Howard University.)

This intriguing scene at the Jonnie Lew's Chinese Laundry was photographed by Gordon Parks in August of 1942. The laundry was located at 1433 Eleventh Street. (Courtesy of Prints and Photographs Division, Library of Congress.)

Photographer Gordon Parks labeled this image "Saturday afternoon at Seventh and Florida Avenue;" he took the photograph in August of 1942. (Courtesy of Prints and Photographs Division, Library of Congress.)

Buildings still extant at the intersection of Seventh and U Streets, as well as the lights of the demolished Griffith Stadium, can bee seen in the reflection of this window display photographed by Gordon Parks in August of 1942. (Courtesy of Prints and Photographs Division, Library of Congress.)

The photo of this panhandler was taken by Gordon Parks on Seventh Street in August of 1942. (Courtesy of Prints and Photographs Division, Library of Congress.)

A shopper purchasing items in a store at the corner of Seventh and U Streets was photographed by Gordon Parks in August of 1942. (Courtesy of Prints and Photographs Division, Library of Congress.)

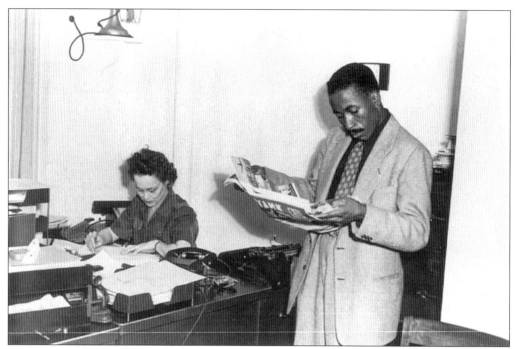

Well-known photographer Gordon Parks, seen here in the Farm Security Administration Office with Charlotte Aiken in 1943, spent his career creating some of America's most important documentary photographs of black society, covering all conceivable aspects of the contemporary black experience. (Courtesy of Prints and Photographs Division, Library of Congress.)

This image is of streetcar on U Street passing the intersection with Seventh Street in August of 1942. (Courtesy of Prints and Photographs Division, Library of Congress.)

A clerk reaches for a bottle in the Standard Drug Store at 1748 Seventh Street in 1938. The store was one of the many white-owned businesses serving a predominantly black population that the New Negro Alliance picketed for discrimination. (Courtesy of Moorland-Spingarn Center, Howard University.)

The Casbah nightclub was one of the many clubs, entertainment venues, and after-hours clubs that once dotted the stretch of U Street from Sixth to Eighteenth Street. The skylight on the ornate building, seen in the ad near the moon, can still be seen on the structure at 1211 U Street. (Courtesy of Henry P. Whitehead.)

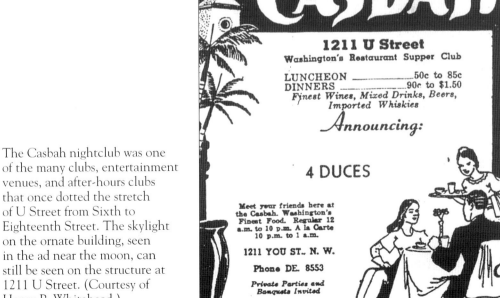

The CASBAH

**1211 U Street**
Washington's Restaurant Supper Club

LUNCHEON ——————50c to 85c
DINNERS ——————90c to $1.50
*Finest Wines, Mixed Drinks, Beers, Imported Whiskies*

*Announcing:*

**4 DUCES**

Meet your friends here at the Casbah. Washington's Finest Food. Regular 12 a.m. to 10 p.m. A la Carte 10 p.m. to 1 a.m.

**1211 YOU ST., N. W.**

**Phone DE. 8553**

*Private Parties and Banquets Invited*

Fire Station Number Four at 913 R Street was organized as a black station in 1919 at the request of one of the four African American firemen who worked in the city. It was his belief that it might be his only opportunity for advancement. (Courtesy of Prints and Photographs Division, Library of Congress.)

Members of the fire station at 913 R Street were responding to a call when this picture was taken by Gordon Parks in January of 1943. (Courtesy of Prints and Photographs Division, Library of Congress.)

Members of Fire Station Number Four were photographed inside their station at 913 R Street in January of 1943 by Gordon Parks. (Courtesy of Prints and Photographs Division, Library of Congress.)

Members of Fire Station Number Four work on their trucks in the 900 block of R Street. Despite being segregated, they were expected to fight fires all across the city. (Courtesy of Prints and Photographs Division, Library of Congress.)

The large auditorium at the True Reformer Building was utilized for a variety of performances, including a run of "Laugh It Off," as seen in this undated advertisement from the era. (Courtesy of Henry P. Whitehead.)

Unknown to the performing world, a young Harry Belafonte got his start at Lewis and Alex's restaurant at 1211 U Street in 1947. Unbelievably, management fired him after a single unmemorable set. He was photographed here by Carl Van Vechten in February of 1954. (Courtesy of Prints and Photographs Division, Library of Congress.)

This photograph shows an unidentified restaurant scene along U Street in the 1940s, typical of the eating establishments of the day. (Courtesy of Prints and Photographs Division, Library of Congress.)

These distinguished members of the M.W. Prince Hall Masonic Lodge pose at their impressive building at 1000 U Street in the 1940s. The lodge is named after the first black freemason, Prince Hall, who began the trade in Boston in 1765. The building at Tenth and U Streets was designed by African-American architect Albert I. Cassell in 1922. (Courtesy of Washingtoniana Division, MLK Public Library.)

These students were photographed at Armstrong Technical High School in the 1940s. In pre-1954 segregated Washington, Armstrong served as the black technical high school, while McKinley High School served whites in technical secondary education. (Courtesy of Prints and Photographs Division, Library of Congress.)

These industrious youngsters are attending a drawing class as part of the Metropolitan Police Boys' Club at the True Reformer Building at Twelfth and U Streets in the 1940s. The class was taught by a D.C. Federal Art Project teacher as part of the Works Progress Administration. (Courtesy of Prints and Photographs Division, Library of Congress.)

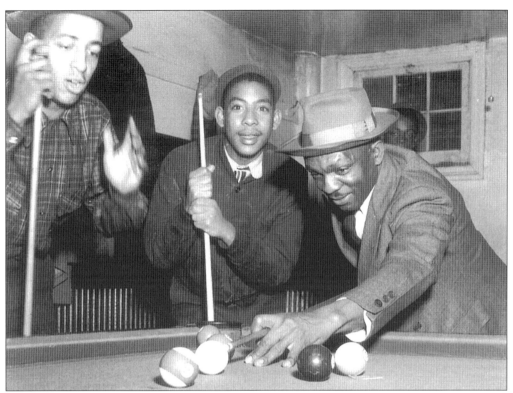

These young boys being mentored by an elder neighborhood citizen were captured at the Idle Hour Billiard Parlor on U Street, one of the many pool halls dotting the U Street corridor. They were photographed by Robert H. McNeill. (Courtesy of Historical Society of Washington.)

The stretch of Fourteenth Street between Logan Circle and Florida Avenue once served as the core of Washington's automobile sales and servicing establishment. Pictured is a DeSoto dealership at 1711 Fourteenth Street. (Courtesy of Prints and Photographs Division, Library of Congress.)

Washington's own Edward "Duke" Ellington was a frequent performer at the Howard Theater and countless other after-hours clubs along the U Street corridor. This image was taken in May of 1943 by Gordon Parks. (Courtesy of Prints and Photographs Division, Library of Congress.)

Not all of the entertainers at the famed Howard Theater were musical. Manager "Shep" Allen—"D.C.'s Dean of Show Biz"— booked black athletic heroes such as Jackie Robinson, Sugar Ray Robinson, and boxer Joe Louis, seen here. (Courtesy of Prints and Photographs Division, Library of Congress.)

Charles Hamilton Houston grew up at 1744 S Street and became known as "Mr. Civil Rights." This nickname stemmed from his admiration of Supreme Court Justice Thurgood Marshall during the *Brown vs. Board of Education* case that was the final assault on segregated education in the United States. (Courtesy of Prints and Photographs Division, Library of Congress.)

Firefighters fight a major fire at 1332 V Street that threatened the nearby Republic Theater at 1343 U Street in this undated *Washington Daily News* photograph by Lawrence Krebs. (Courtesy of Washingtoniana Division, MLK Public Library.)

This mixed crowd at Griffith Stadium awaits tickets to an event in 1947. The stadium was one of the few public places never racially segregated. (Courtesy of Washingtoniana Division, MLK Public Library.)

A youngster is photographed washing his car in the 1400 block of S Street in 1950. (Courtesy of Historical Society of Washington.)

Sarah Vaughn, Billie Holiday, and Louis Armstrong were only three of the many famous musicians that played at U Street venues, including Club Bali. Sarah Vaughn is shown here accepting an award from the club in 1947. (Courtesy of Historical Society of Washington.)

This scene on Florida Avenue south of W Street shows several wood frame houses that were constructed before 1878 when the city building codes began calling for all-brick construction. Pictured here on May 15, 1949, the tiny dwellings were later replaced by a car washing facility. (Courtesy of Historical Society of Washington.)

The Florida Avenue Baptist Church near Wiltburger Street was photographed by John Wymer on October 11, 1949. (Courtesy of Historical Society of Washington.)

The Potomac Electric Power Company's service station at the corner of Tenth and W Streets was captured by photographer John Wymer on June 12, 1949. The service station was later purchased by Howard University and is run as a storage facility today. (Courtesy of Historical Society of Washington.)

Built in 1929, this is a photo of the Garnet-Patterson School at Tenth Street and Vermont Avenue on October 11, 1949. (Courtesy of Historical Society of Washington.)

The Garfield Memorial Hospital at Tenth Street and Florida Avenue was photographed by John Wymer on May 15, 1949. (Courtesy of Historical Society of Washington.)

The elegant entrance to Garfield Memorial Hospital, pictured here in 1949, can still be seen today, along with the iron fence that surrounds the high-rise housing site today. (Courtesy of Historical Society of Washington.)

The old Cardozo High School at Ninth Street and Rhode Island Avenue, part of the black school system, was photographed in 1949, just a year before it was abandoned. Its students were transferred to Central High School at Twelfth Street and Florida Avenue. The building was torn down shortly thereafter. (Courtesy of Historical Society of Washington.)

These houses on the north side of the 1200 block of T Street were built in the early 1870s. The three or four houses at left were torn down shortly after this photograph was taken on November 23, 1950, and were replaced with a four-story apartment building that remains on the site today at Thirteenth and T Streets. (Courtesy of Historical Society of Washington.)

The elegant Booker T Theater at 1435 U Street was photographed by John Wymer in 1949. Named after Booker T. Washington, it stood on the site of what is today the Reeves Municipal Building at the intersection of Fourteenth and T Streets. (Courtesy of Historical Society of Washington.)

These children are pictured playing on the south side of T Street on September 3, 1949. This photo was taken by John Wymer. (Courtesy of Historical Society of Washington.)

This portion of Thirteenth Street between S and T Streets was photographed by John Wymer on September 3, 1949. Note the elegant wrought iron cresting on top of each bay window. (Courtesy of Historical Society of Washington.)

This entire block of buildings and homes, in the 1700 block of Vermont Avenue, north of R Street, was torn down in the 1960s to make way for the Garrison Elementary School and ball field. The block as it appeared before the school was built is shown here in a photograph taken on September 4, 1949. (Courtesy of Historical Society of Washington.)

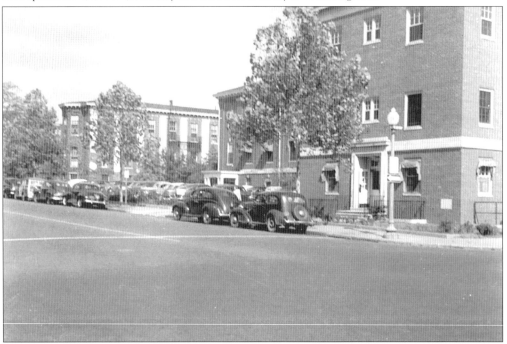

Children's Hospital at Thirteenth and V Streets was photographed on October 4, 1949, showing the patchwork of additions to the facility added throughout its existence from 1878 to 1995. (Courtesy of Historical Society of Washington.)

The Industrial Bank building and a portion of Thompson's Dairy can be seen in this October 4, 1949 view of the northwest corner of Eleventh and U Streets. (Courtesy of Historical Society of Washington.)

Grimke Elementary School, located on Vermont Avenue between T and U Streets, was named after Archibald Grimke, a mulatto. His father was white and his mother was a former slave. Grimke would become a prominent lawyer and civil rights leader, eventually residing in the 1400 block of Corcoran Street. The Grimke school was built in 1937 as an addition to the Phelps School, at left, built in 1887. The school was photographed on October 4, 1949. (Courtesy of Historical Society of Washington.)

The Sunny South Market occupied the corner store at Fourteenth and T Streets when this picture was taken on September 3, 1949. (Courtesy of Historical Society of Washington.)

The 1800 block of Fourteenth Street has remained virtually unchanged since this photograph was taken on September 3, 1949. The Studio Theater now occupies the building built for the Standard Auto Supply Store, at center. (Courtesy of Historical Society of Washington.)

These three frame houses on New Hampshire Avenue just south of U Street were photographed on September 3, 1949. (Courtesy of Historical Society of Washington.)

The one-block length of Seaton Place, which runs between Seventeenth and Eighteenth Streets between U and V Streets, was captured by John Wymer on November 11, 1949. Most of the block was built in the 1890s, with those homes at 1743–1747 completing the block in 1905. (Courtesy of Historical Society of Washington.)

This picture, taken on October 4, 1949, shows the buildings on the north side of U Street looking east. The three large structures at far right were torn down in the 1970s, in anticipation of Metro construction. Among the losses was the renowned Republic Theater. (Courtesy of Historical Society of Washington.)

These homes on the north side of the 1400 block of Florida Avenue, near Fourteenth Street, were constructed before 1878. The topography shown in this photograph indicates that Florida Avenue had been leveled out by the time this photograph was taken on October 4, 1949. The homes have since been replaced with small apartment buildings. (Courtesy of Historical Society of Washington.)

The Roosevelt Hotel at 2101 Sixteenth Street was designed by architect Appleton P. Clark and built in 1919. It originally contained 168 hotel rooms and 126 apartments that were popular with members of Congress. It was purchased by the city and converted into a housing complex for senior citizens in 1963. After a protracted battle for purchase and redevelopment rights, the building has begun rehabilitation as luxury condominiums. It is pictured here in a photograph taken by John Wymer on September 10, 1949. (Courtesy of Historical Society of Washington.)

On the north side of U Street, just east of Seventeenth, were the Roberts Brothers automobile service center, the H.B. Leary Company building, and an elegant round bay-fronted building. This image was taken on November 11, 1949. All were razed in 1974 to make way for the parking garage of the Third District Police station that exists on the site today. (Courtesy of Historical Society of Washington.)

This large and impressive Presbyterian Church at the northwest corner of Fifteenth and R Streets, seen here on October 4, 1949, was later torn down and replaced with the present-day church of 1970s design. (Courtesy of Historical Society of Washington.)

This photograph, dated October 4, 1949, shows what was then a partially completed St. Augustine's Church at 1715 Fifteenth Street on the right. The chapel, school, and convent are pictured at left. The smaller buildings were completed in 1929, and the church was begun in 1933. However, in the face of financial difficulties, the church abandoned both properties and merged with St. Paul's Church at Fifteenth and V Streets. Today, the Bishop's Gate condominium complex occupies the site, built atop the foundation of the church. (Courtesy of Historical Society of Washington.)

These homes in the 1300 block of S Street had fallen onto hard times by the time this photograph was taken on September 3, 1949. Built as a matching row in the early 1870s, the three homes at right received a third-floor addition in the 1890s. (Courtesy of Historical Society of Washington.)

The old Denison School once occupied the north side of S Street, between Thirteenth and Fourteenth Streets. It is pictured here on September 3, 1949. The site is now occupied by the D.C. Department of Parks and Recreation. (Courtesy of Historical Society of Washington.)

One of the city's longest lasting businesses, the Whitelaw Market, named after John Whitelaw Lewis and the Whitelaw Hotel opposite, operates to this day under the same name at the corner of Thirteenth and T Streets. It is pictured here on October 4, 1949. (Courtesy of Historical Society of Washington.)

Peyser's Market was once located at the northwest corner of Thirteenth and S Streets, as seen in this photograph dated September 3, 1949. It was later modified into a residential structure that remains to this day, though it has since been altered. (Courtesy of Historical Society of Washington.)

# One

# FROM TRANQUILITY TO TURMOIL

## 1950 TO 1970

*Despite aging buildings and homes, the Greater U Street area continued to thrive well into the 1950s and 1960s. Older clubs like the Bohemian Caverns continued to offer the best entertainment for a diverse clientele, while new clubs opened to enthusiastic crowds from all over the metro area. The former Portner Flats apartment building at Fifteenth and U Street was converted into a luxury hotel and apartment building serving an elite African-American clientele and renamed The Dunbar Hotel in honor of local poet Paul Lawrence Dunbar. At the time, it was the largest black-owned hotel in the United States, and played host to a variety of entertainers, sports figures, and Howard University faculty. The white congregation at St. Paul's Roman Catholic Church at Fifteenth and V merged with the black congregation of St. Augustine's Church in 1961, and now occupies the 1883 Gothic Revival building. Throughout the 1960s, black and white Washingtonians often mixed in Meridian Hill Park to enjoy one of the many outdoor concerts or early Civil Rights rallies.*

*The tranquility of the neighborhood changed to turmoil after the assassination of Dr. Martin Luther King Jr. on April 4, 1968, only five years after his famous "I Have a Dream" speech made on the steps of the Lincoln Memorial. The intersection of Fourteenth and U Street was one of the first areas of the city that was subject to rioting and looting. Other areas included Seventh Street, Fourteenth Street into Columbia Heights, H Street on Capitol Hill, and downtown stores. The rioting continued throughout the summer in small pockets, and revived in October of 1968 along Fourteenth Street. Federal troops were stationed at several points in the neighborhood by request of the president. This period of turmoil laid the groundwork for an abandonment of the neighborhood and the city itself by both black and white families. This movement would take decades to reverse.*

This row of elegant buildings on the north side of U Street, looking west from Fourteenth Street, included the Booker T Theater. The Portner Flats apartment building can be seen in the background of this image, taken in 1950. The row was demolished to make way for the Reeves Municipal Building in the early 1980s and the Portner was torn down in 1974 and replaced in 1978 with the Campbell Heights senior housing complex. (Courtesy of Historical Society of Washington.)

Little has changed along the south side of the 1600 block of U Street since this image was taken on August 26, 1951. The Chrysler dealership in the center was converted into a gym in the late 1990s following a decade of disuse. (Courtesy of Historical Society of Washington.)

John Wymer photographed the 1500 block of Seventh Street, between P and Q Streets, on November 15, 1950. The Broadway Theater was later replaced by a parking lot. (Courtesy of Historical Society of Washington.)

Police precinct number 15 was once located in this elegant building at the corner of Ninth and U Streets. It was photographed on August 26, 1951. The building no longer stands. (Courtesy of Historical Society of Washington.)

This large and elegant apartment building , pictured here on August 25, 1951, once occupied the northwest corner of Vermont Avenue and T Street before it was destroyed by fire. Automobile parking fills the lot today. (Courtesy of Historical Society of Washington.)

The Beren Baptist Church was photographed by John Wymer on October 15, 1951. It still exists at the corner of Eleventh and V Streets today. (Courtesy of Historical Society of Washington.)

The 1700 block of U Street, seen here in 1951, was built in stages on the south side. The homes at 1751 to 1765 were built in 1902, and the entire north side was built the same year and designed by architect Nicholas T. Haller. (Courtesy of Historical Society of Washington.)

Three people were injured when this car flipped over the sidewalk at Fifteenth and P Streets at 2 a.m. on March 6, 1953. This image was featured in the *Washington Star*. (Courtesy of Washingtoniana Division, MLK Public Library.)

This image shows Garfield Hospital at Tenth Street and Florida Avenue being razed on November 29, 1960. The facility opened on May 30, 1884 and operated until it was shuttered on March 28, 1958. It was torn down for construction of an elementary school and housing project. (Courtesy of Washingtoniana Division, MLK Public Library.)

This dramatic image of the abandoned Garfield Hospital was taken on February 13, 1959 by Randy Routt shortly before it was demolished. (Courtesy of Washingtoniana Division, MLK Public Library.)

Curtis Washington, right, gets it in the nose from Robin Payne during the Police Boys Club boxing matches held frequently in the True Reformer Building. This photograph first appeared in the *Washington Daily News* on March 4, 1967. (Courtesy of Washingtoniana Division, MLK Public Library.)

Riot police throw a tear gas canister into a crowd that had developed at the Empire Liquor at Fourteenth and S Streets, a building that today houses the Whitman Walker AIDS Clinic. (Courtesy of Washingtoniana Division, MLK Public Library.)

Mayor Walter Washington is seen here (at center, with hat), at the corner of Fourteenth and U Streets conferring with police immediately after the civic unrest of April 1968. (Courtesy of Washingtoniana Division, MLK Public Library.)

This riot scene at Fourteenth and U Streets illustrates the large police presence that was required during the civic unrest that began after the assassination of Rev Martin Luther King Jr., in April of 1968 in Memphis, Tennessee. (Courtesy of Washingtoniana Division, MLK Public Library.)

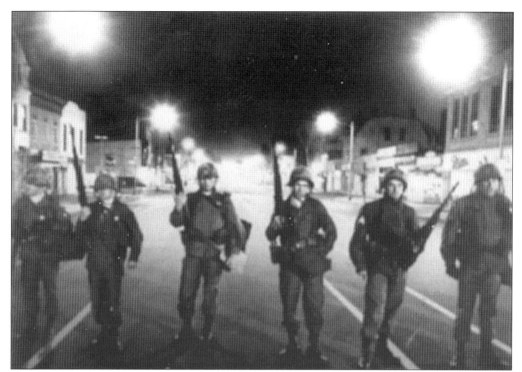

Federal troops in full battle gear patrol Fourteenth Street north of S Street at the request of President Johnson to help control looters. This *Washington Star* photograph was taken on April 5, 1968. (Courtesy of Washingtoniana Division, MLK Public Library.)

The automotive center on Fourteenth Street, north of U Street, suffered a major fire because of the 1968 disturbances. This photograph was taken by Ray Lustig. (Courtesy of Washingtoniana Division, MLK Public Library.)

This dramatic photograph shows police and an armed manager guarding the Safeway store at Fourteenth and U Streets amidst the chaos. (Courtesy of Washingtoniana Division, MLK Public Library.)

An amateur photographer took this quick image of Sen. Robert Kennedy as he walked the 22 blocks of Fourteenth Street that were devastated by rioting on April 7, 1968 after attending Palm Sunday Services. (Courtesy of Washingtoniana Division, MLK Public Library.)

An unidentified local man poses in front of the ruined building at 702 S Street on April 10, 1968. The building was demolished in the racial riots earlier that month. (Courtesy of Washingtoniana Division, MLK Public Library.)

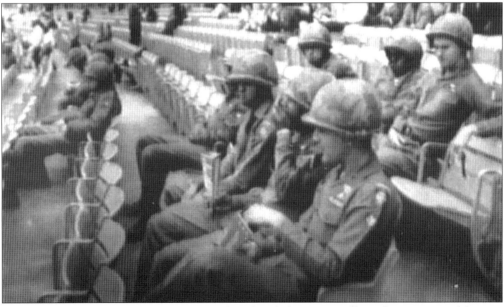

Troops of the 82nd Airborne Division take a break from controlling the rioting and looting at Griffith Stadium a few days before the opening day game between the Washington Senators and the Minnesota Twins on April 10, 1968. (Courtesy of Washingtoniana Division, MLK Public Library.)

This dramatic image of a man rescuing another on Seventh Street was taken on April 6, 1968. (Courtesy of Washingtoniana Division, MLK Public Library.)

This scene at Seventh and P Streets following the riots of 1968 was captured by photographer M.D. Sullivan. (Courtesy of Washingtoniana Division, MLK Public Library.)

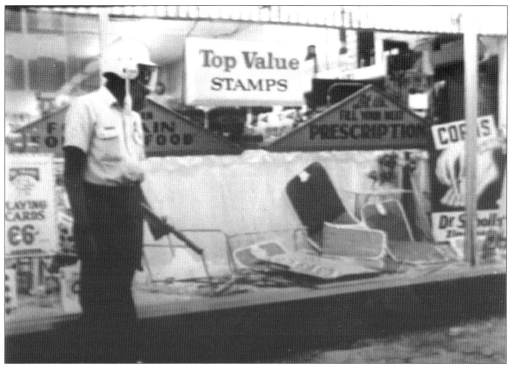

This policeman stands guard at the People's Drugstore at the corner of Fourteenth and U Streets on June 25, 1968. (Courtesy of Washingtoniana Division, MLK Public Library.)

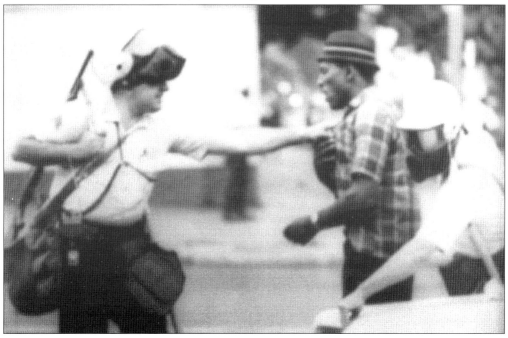

As rioting continued throughout the summer of 1968, several police officers seized a man for questioning at Fourteenth and U Streets on June 25, 1968. (Courtesy of Washingtoniana Division, MLK Public Library.)

This photo of the military police called in by the President was taken on Fourteenth Street by F. Routt on June 24, 1968. (Courtesy of Washingtoniana Division, MLK Public Library.)

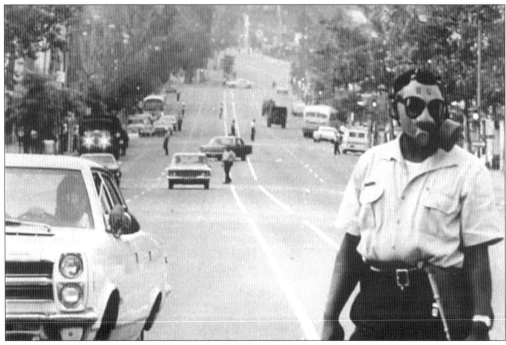

Fourteenth Street traffic was redirected by this gas mask-wearing policeman at S Street when this image was taken on June 24, 1968. This *Washington Star* photograph is by F. Routt. (Courtesy of Washingtoniana Division, MLK Public Library.)

This teenager was arrested at Thirteenth and U Streets on Halloween night in 1968 as part of the racial disturbances in the area. This photo was taken by Ray Lustig. (Courtesy of Washingtoniana Division, MLK Public Library.)

Police and firemen gathered in haste at Fourteenth and Belmont Streets as police chased rioters up Fourteenth Street in early October of 1968. (Courtesy of Washingtoniana Division, MLK Public Library.)

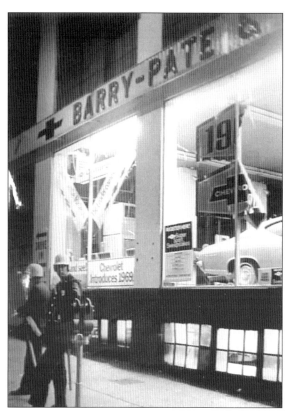

Police stand outside Barry-Pate and Addison on Fourteenth Street in early October 1968 to protect the establishment from further damage during the riots. (Courtesy of Washingtoniana Division, MLK Public Library.)

Police moved into the area at Fourteenth Street and Florida Avenue on November 2, 1968, after a crowd set three cars on fire. The disorder began after a policeman wounded a woman he said threatened him with a butcher knife. The photograph was seen in the *Washington Star*. (Courtesy of Washingtoniana Division, MLK Public Library.)

# One

# RECOGNIZING AND
# REBUILDING
## 1970 TO 1990S

*With many burned and ruined buildings remaining for years, citizens of the neighborhood were reminded daily of the devastation the rioting had caused on the once peaceful community. However, many families and business owners chose to remain in the corridor and begin the process of rebuilding the grand avenue. The 1970s was an era where new entrepreneurs could establish a business on U Street, such as John "Butch" Snipes, who opened up a clothing store adjacent to the Lincoln Theater and led the U Street Business Association. Others formed organizations such as the Fourteenth and U Street Coalition to advocate civic improvements and safety.*

*The Historic American Building Survey (HABS) documented several prominent buildings in the neighborhood with extensive measuring drawings and photographs, beginning in 1970. They included the True Reformer Building at 1200 U Street, the Twelfth Street YMCA at 1816 Twelfth Street, and the abandoned Whitelaw Hotel at Thirteenth and T Streets. The Cardozo Shaw Neighborhood Association was formed by resident Jeffrey Koenrich and others in 1984, who initiated an in depth history survey of the area beginning in 1991. This led to the entire area surrounding the U Street corridor being deemed a local and national historic district in 1999.*

This building, once located at the southeast corner of Fourteenth and Wallach Place, was known as the "Franklin Building." It is pictured here in the March 27, 1970 edition of the *Washington Star*, shortly before its demolition. (Courtesy of Washingtoniana Division, MLK Public Library.)

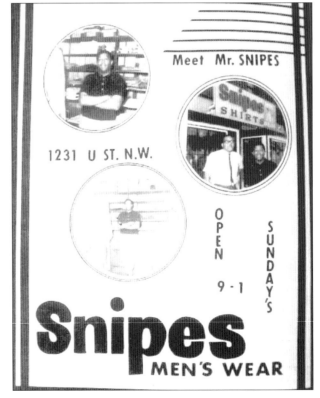

Not all businesses and residents fled the U Street area after the 1968 riots. In fact, many locals established new shops and restaurants along the corridor in the 1970s. Longtime resident John "Butch" Snipes opened a clothing shop at 1231 U Street, and others established a variety of community organizations like the Fourteenth and U Coalition. (Courtesy of John Snipes.)

The Twelfth Street YMCA was also a victim of hard times in the U Street corridor, and finally closed it doors in the mid-1980s. The large apparatus on the roof is an air raid warning siren left over from World War II. (Courtesy of the Historic American Buildings Survey, Library of Congress.)

The Twelfth Street YMCA was built in 1909 with a swimming pool on its basement level. By 1970, as seen in this photo, the pool had fallen victim to neglect and disrepair along with the rest of the building. (Courtesy of the Historic American Buildings Survey, Library of Congress.)

The True Reformer Building at 1200 U Street was also abandoned by the 1970s. Only the ground floor was in use, as a Duron Paint store. Even the paint store closed eventually, about 1994. Pictured here in 1970, at the beginning of its downfall, the building waited nearly 30 years for a new lease on life. In 2000, it was purchased by a non-profit philanthropic foundation for use as a community center and foundation headquarters. (Courtesy of the Historic American Buildings Survey, Library of Congress.)

The two-story auditorium in the True Reformer Building at Twelfth and U Streets, designed by noted African-American architect John A. Lankford, was once the sight of many African-American festivities, meetings, parties, and performances. By the time this photograph was taken in 1970, the beautiful, spacious auditorium had been chopped into office and storage spaces by the only tenant of the building, Duron Paint. (Courtesy of the Historic American Buildings Survey, Library of Congress.)

The once elegant Whitelaw Hotel, built in 1919 at Thirteenth and T Streets, fell onto hard times by the time it was captured in this photograph in 1970. Abandoned by its rightful tenants, it became home to countless prostitutes and homeless people who took advantage of its easy access to make shelter. (Courtesy of the Historic American Buildings Survey, Library of Congress.)

Sitting abandoned for decades until its 1990 rehabilitation, the interior of the Whitelaw Hotel suffered tremendous damage. Fortunately, many important architectural elements survived the period of abandonment. A stained glass ceiling, originally from the grand dining room, was miraculously found in a neighbor's garage and rescued. (Courtesy of the Historic American Buildings Survey, Library of Congress.)

One of the first owners of a newly renovated, moderate-income apartment in the Whitelaw was actually a reformed prostitute who used the building to turn tricks during its period of abandonment in the 1970 and 1980s. The once elegant dining room buffet is seen above in 1970. (Courtesy of the Historic American Buildings Survey, Library of Congress.)

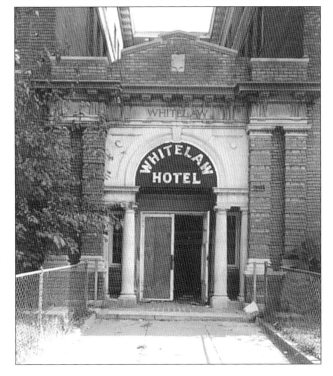

Remarkably, the Whitelaw Hotel name has remained on the building from 1919 to this day. MANNA, Inc., a local non-profit housing developer, completely renovated the building into a successful moderate-income housing building in 1990. (Courtesy of the Historic American Buildings Survey, Library of Congress.)

Fans of Bill Cosby flock the performer during one of his many visits to Ben's Chili Bowl. Opened in 1958, the restaurant delivers Cosby's favored "half-smokes" to the celebrity around the world upon request; occasionally it makes deliveries to the comedian by surprise, as happened most recently during a live Oprah show. (Courtesy of Ben's Chili Bowl, 1213 U Street.)

This building at Fourteenth and U Streets originally housed Club Bali. Jazz greats and famous black musicians performed at Club Bali in the 1930s and 1940s. The building was abandoned for many years before being reclaimed by the Living Stage Theater Company in recent years. (Courtesy of Washingtoniana Division, MLK Public Library.)